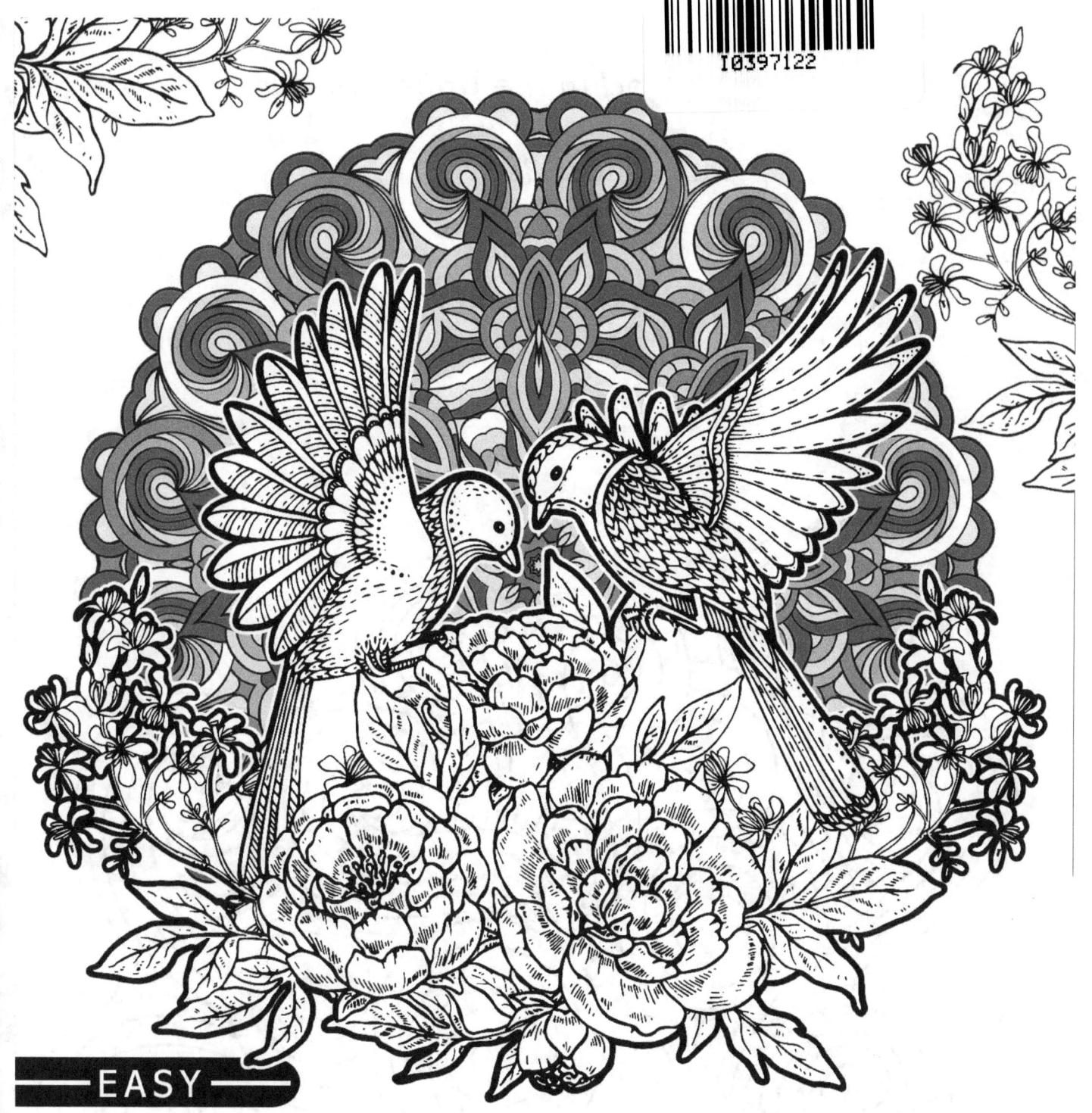

Copyright: Published in the United States

Published 2017

All rights reserved.

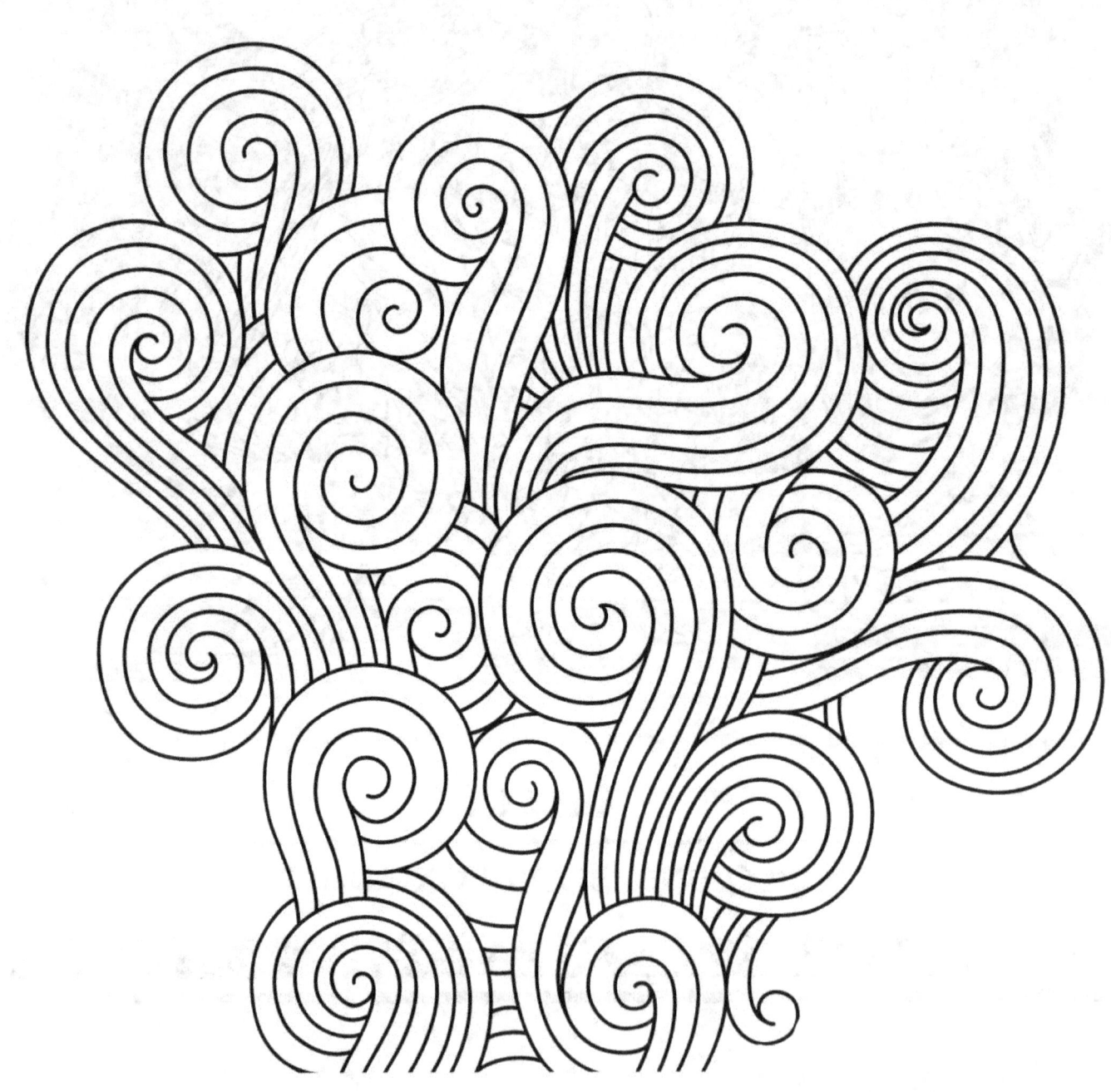

TEST YOUR COLOR HERE

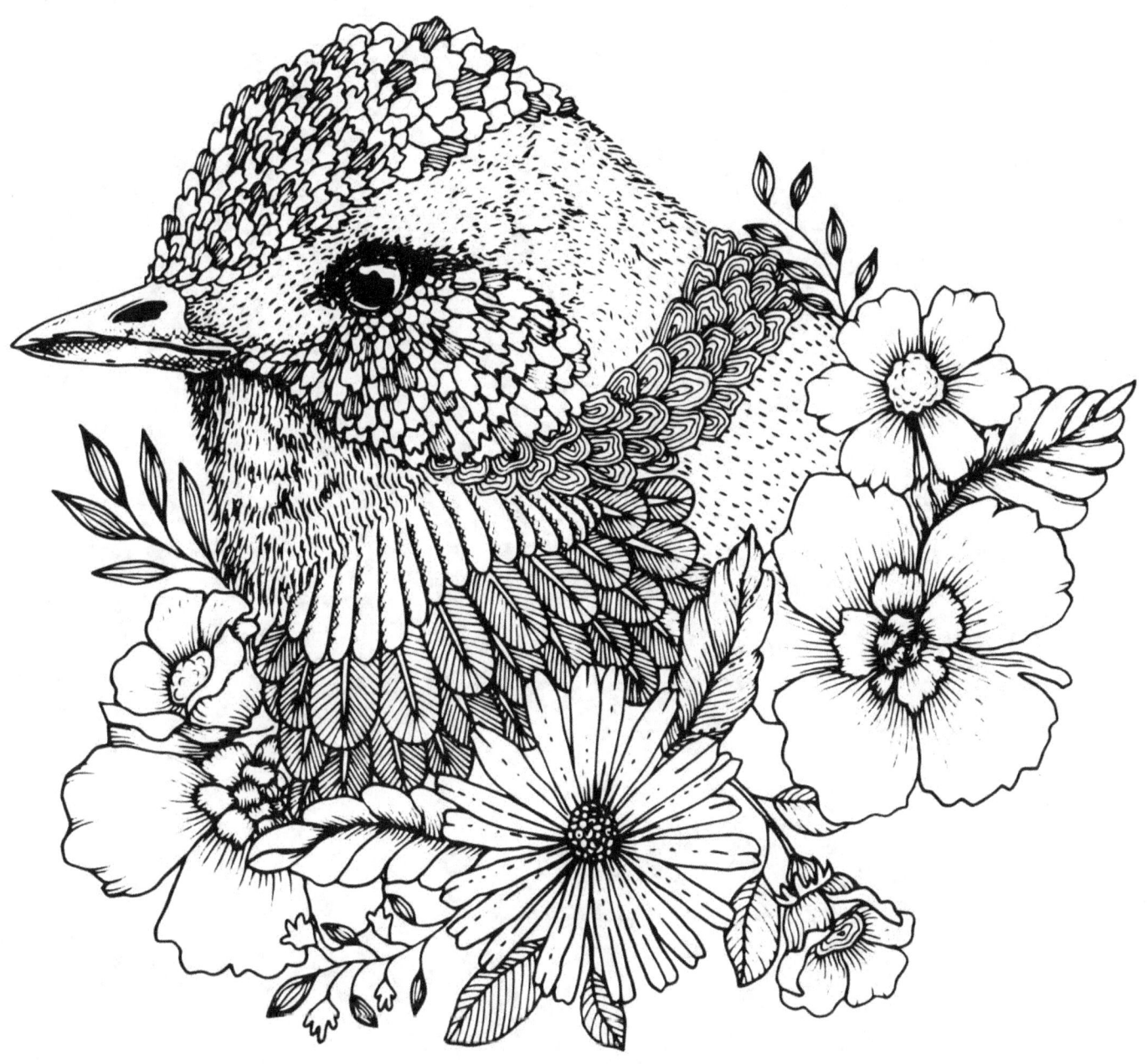

TEST YOUR COLOR HERE

1.

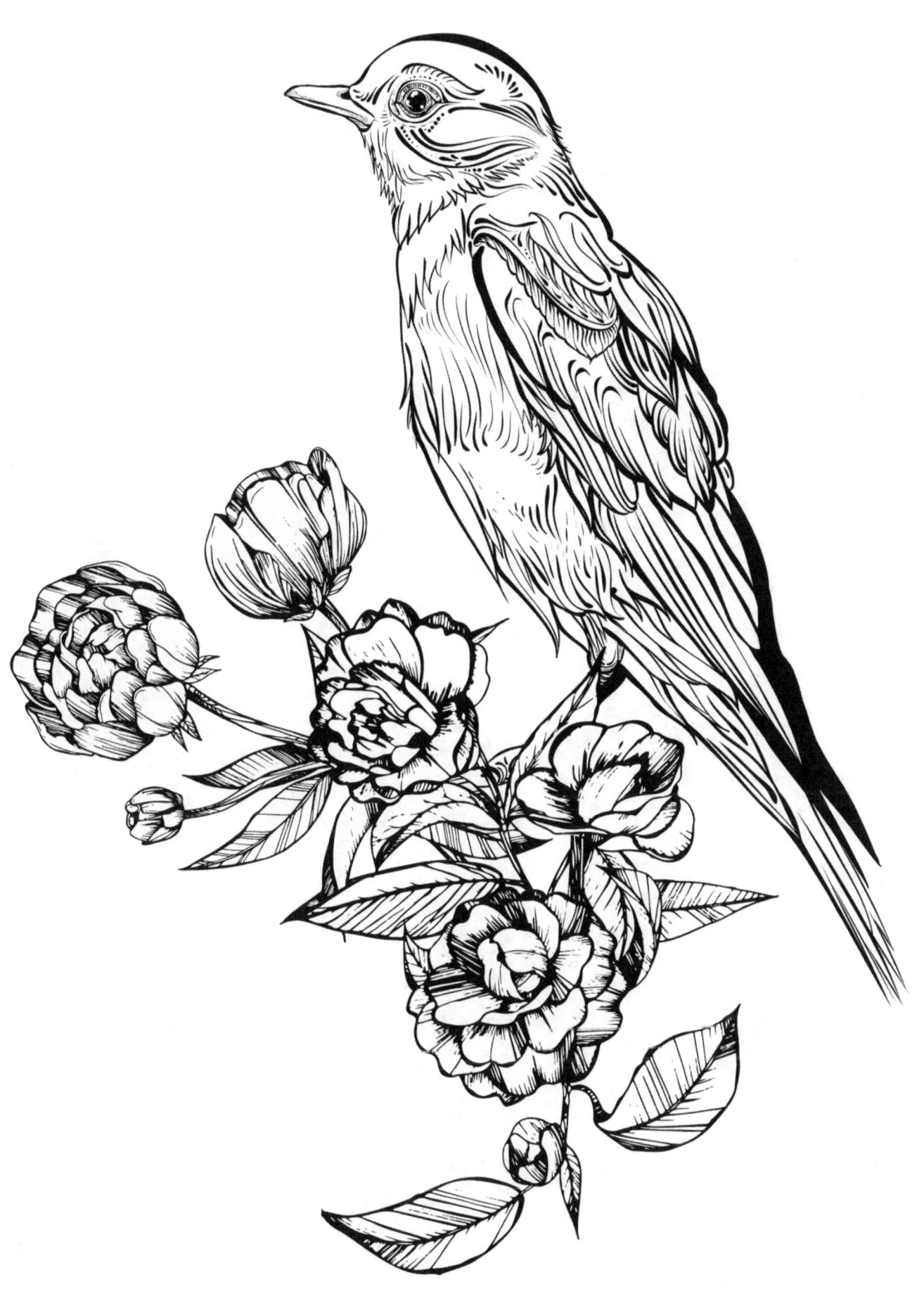

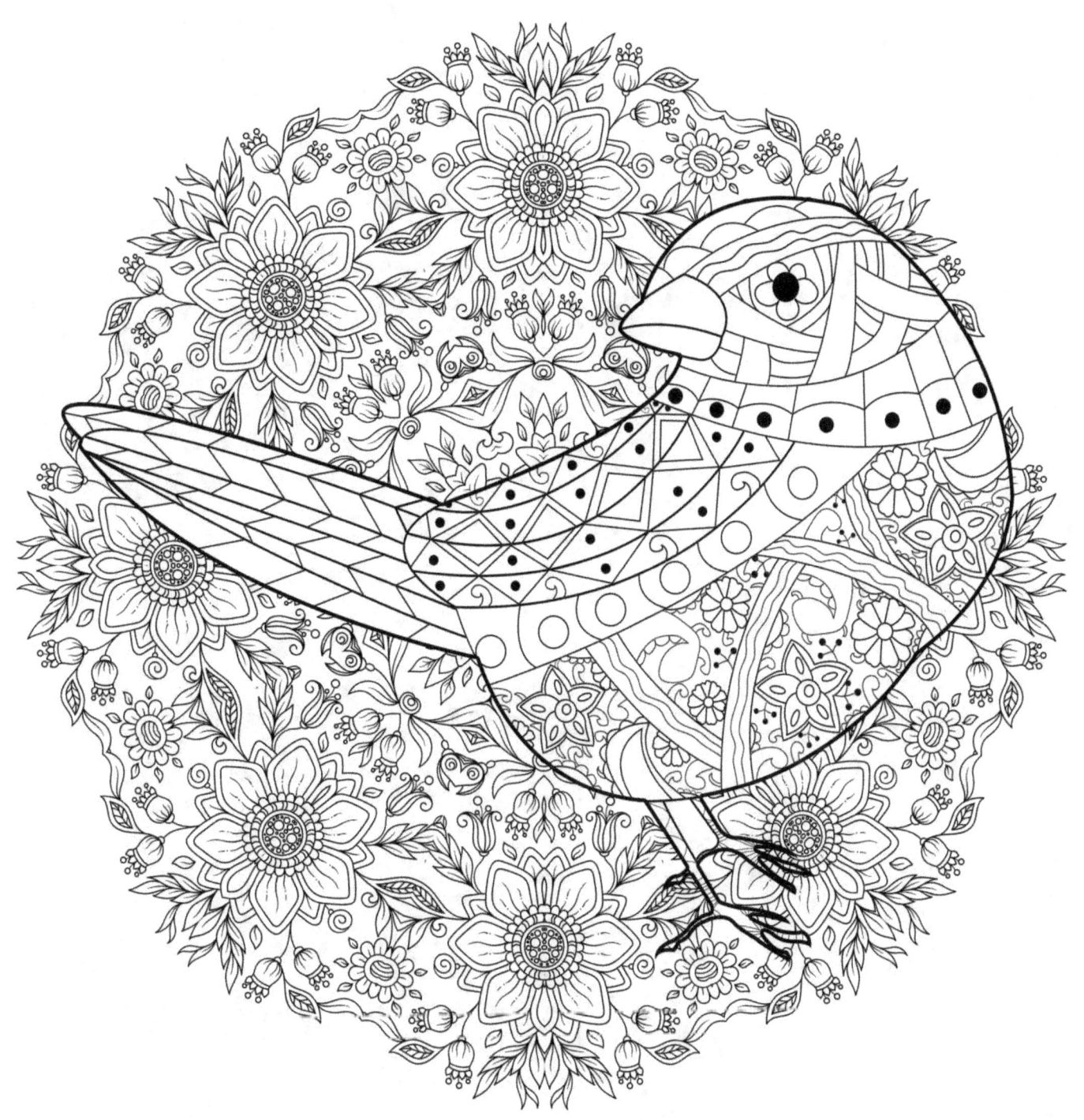

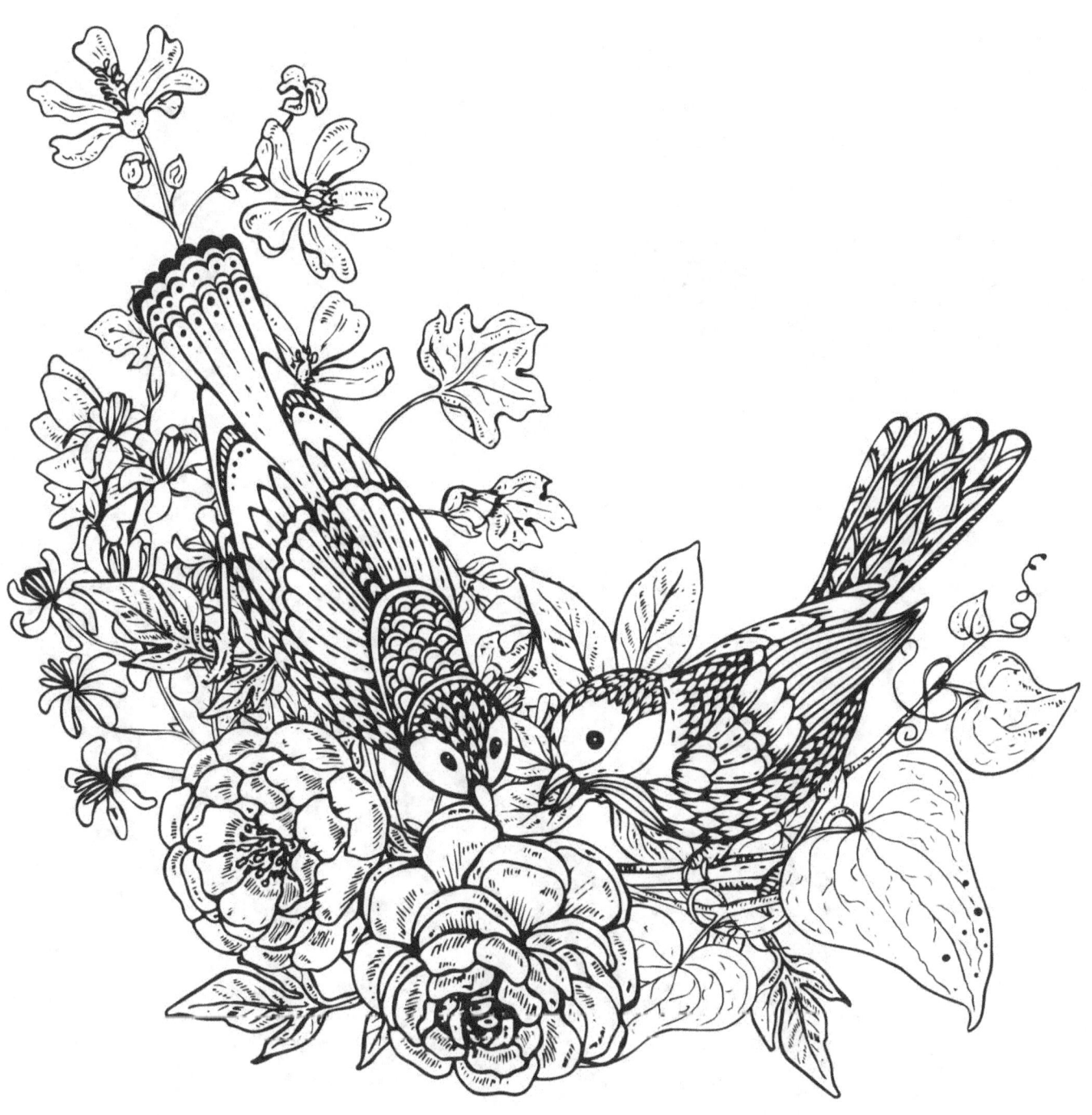

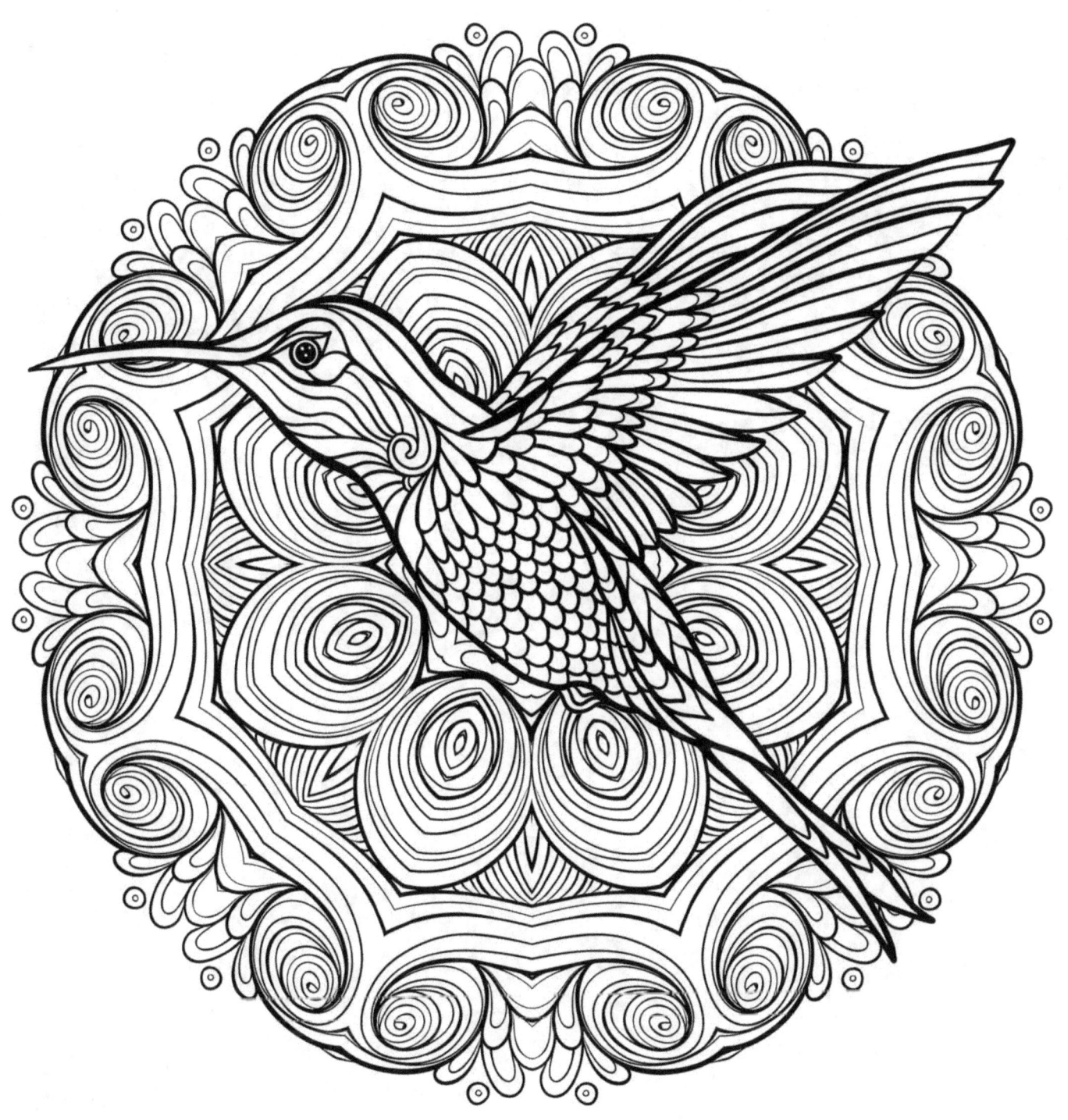

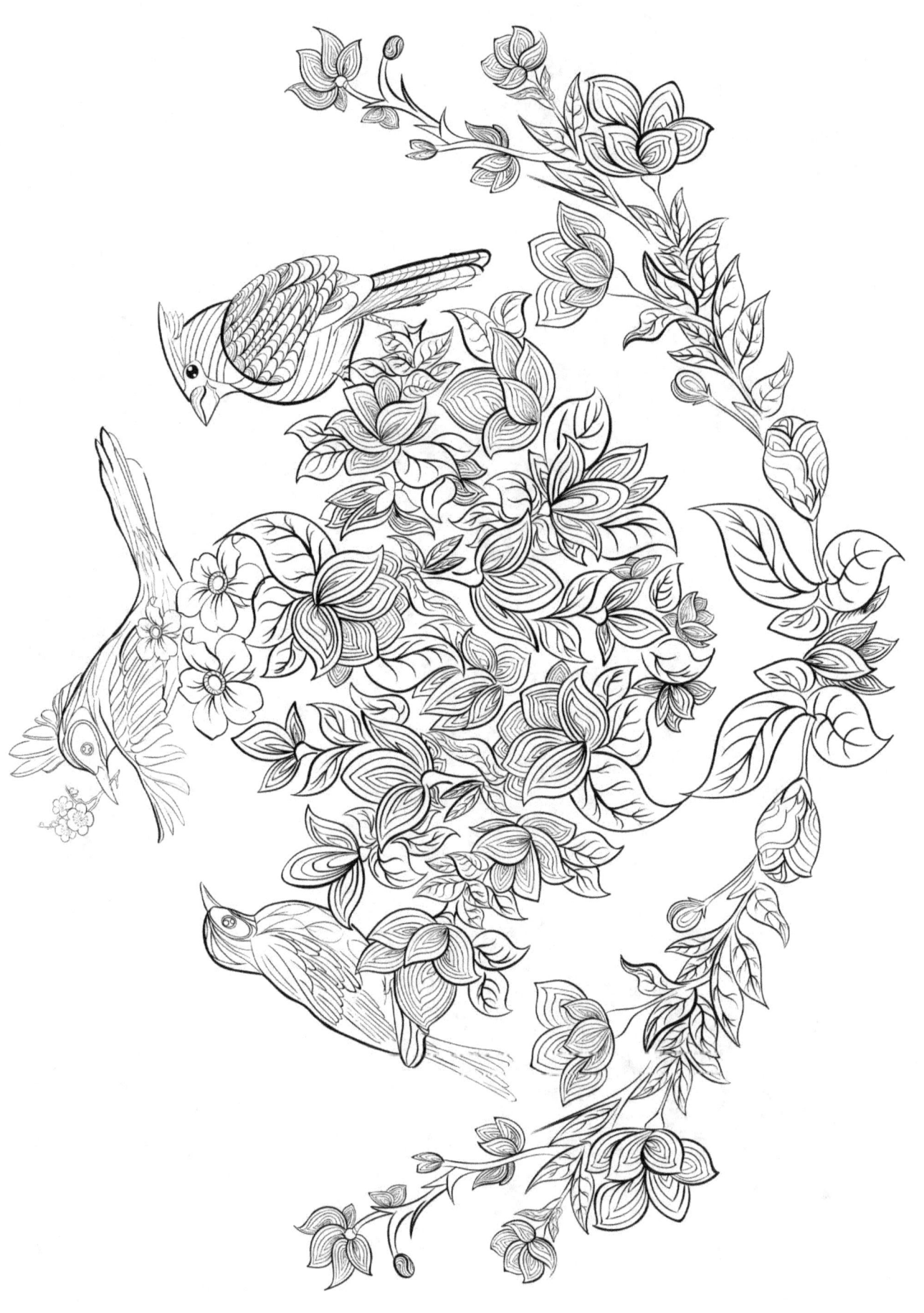

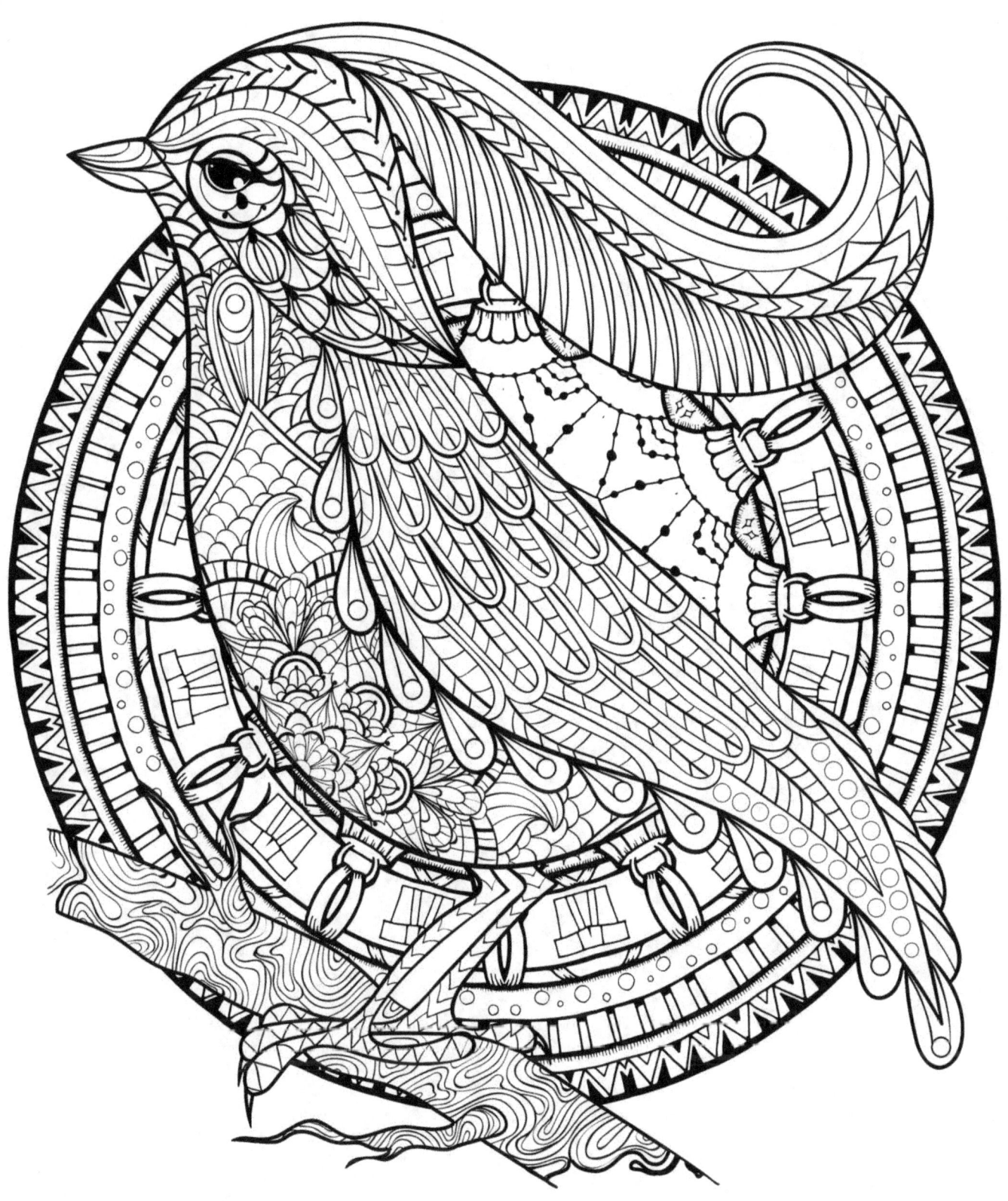

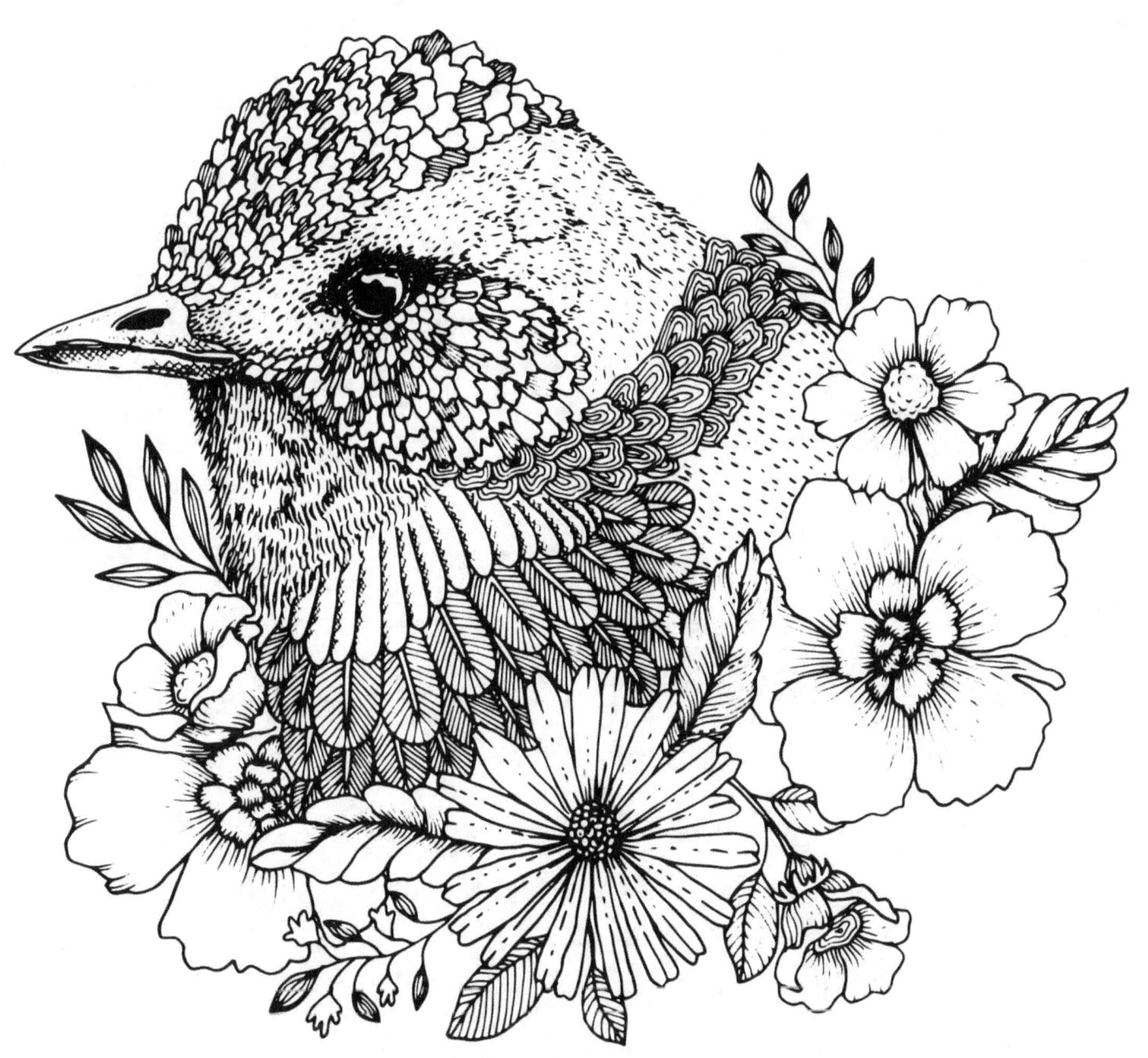

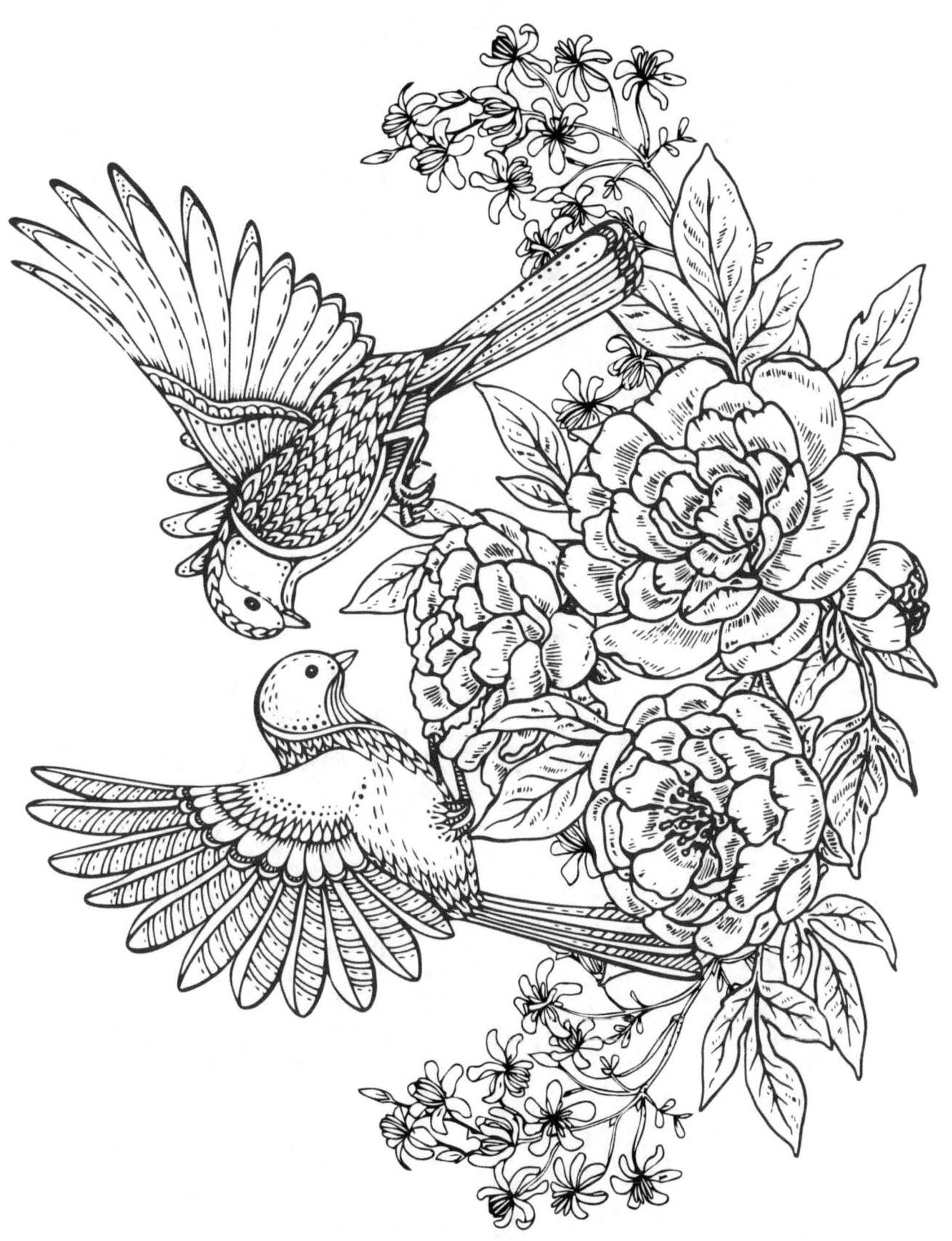

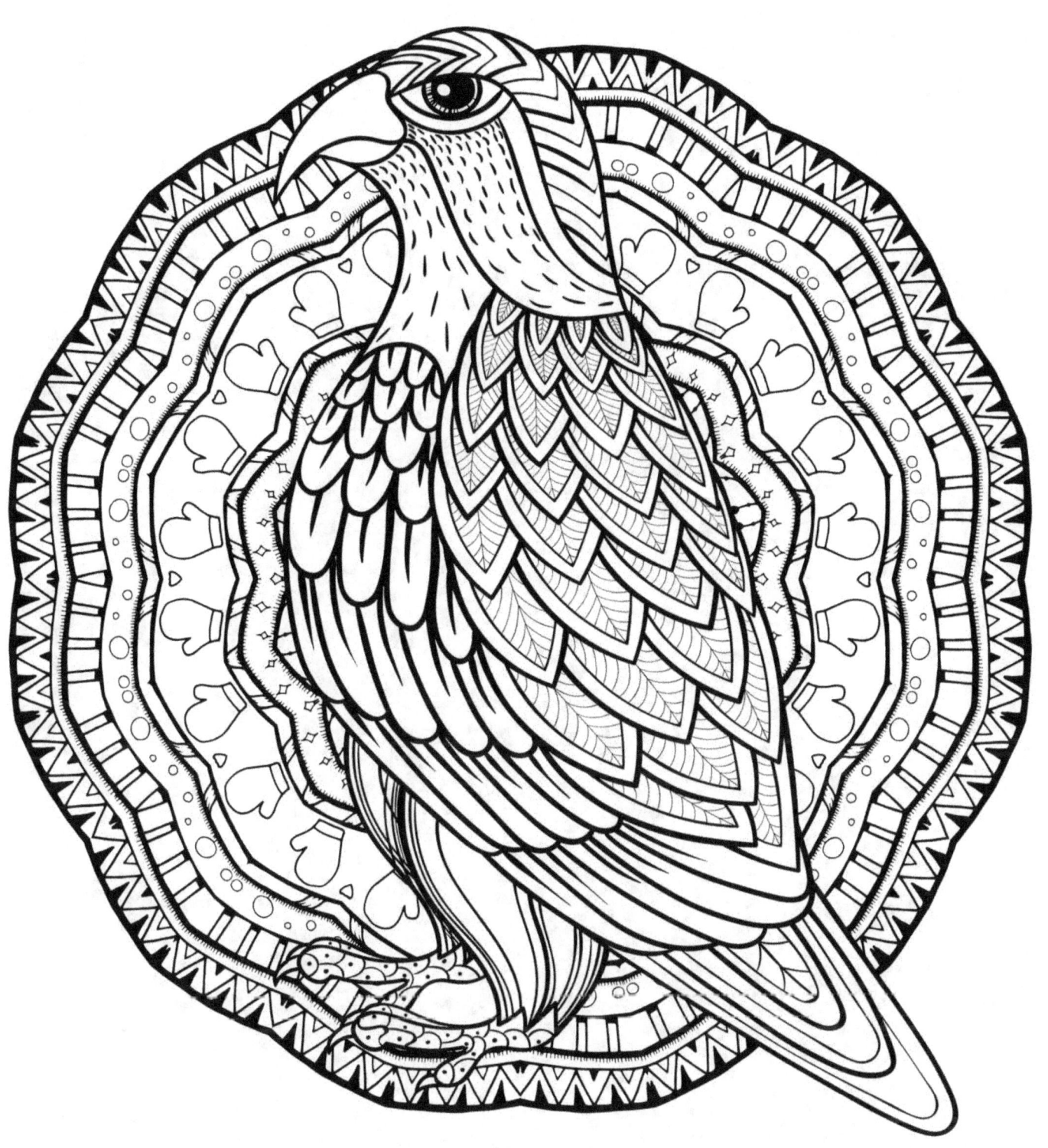

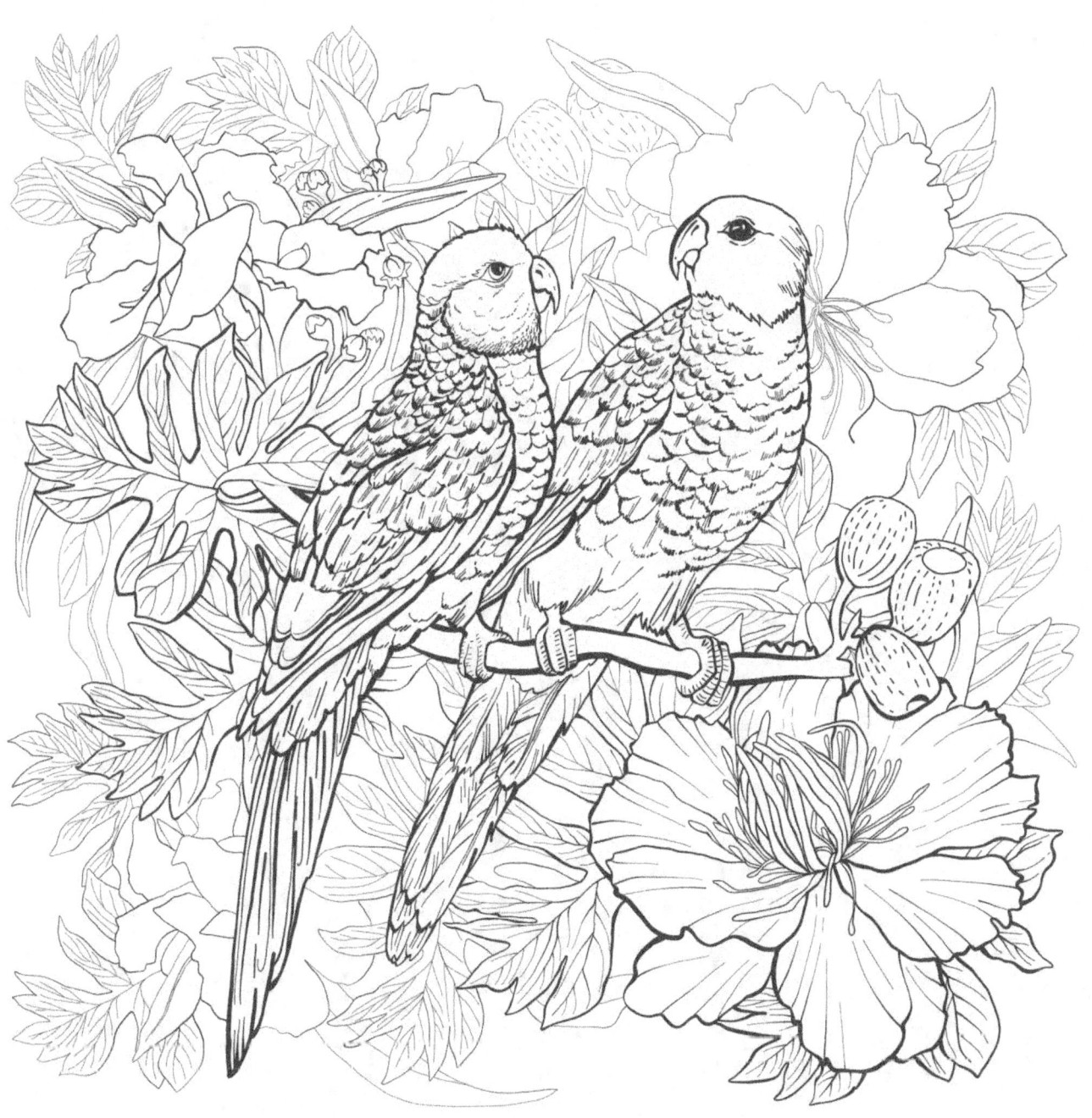

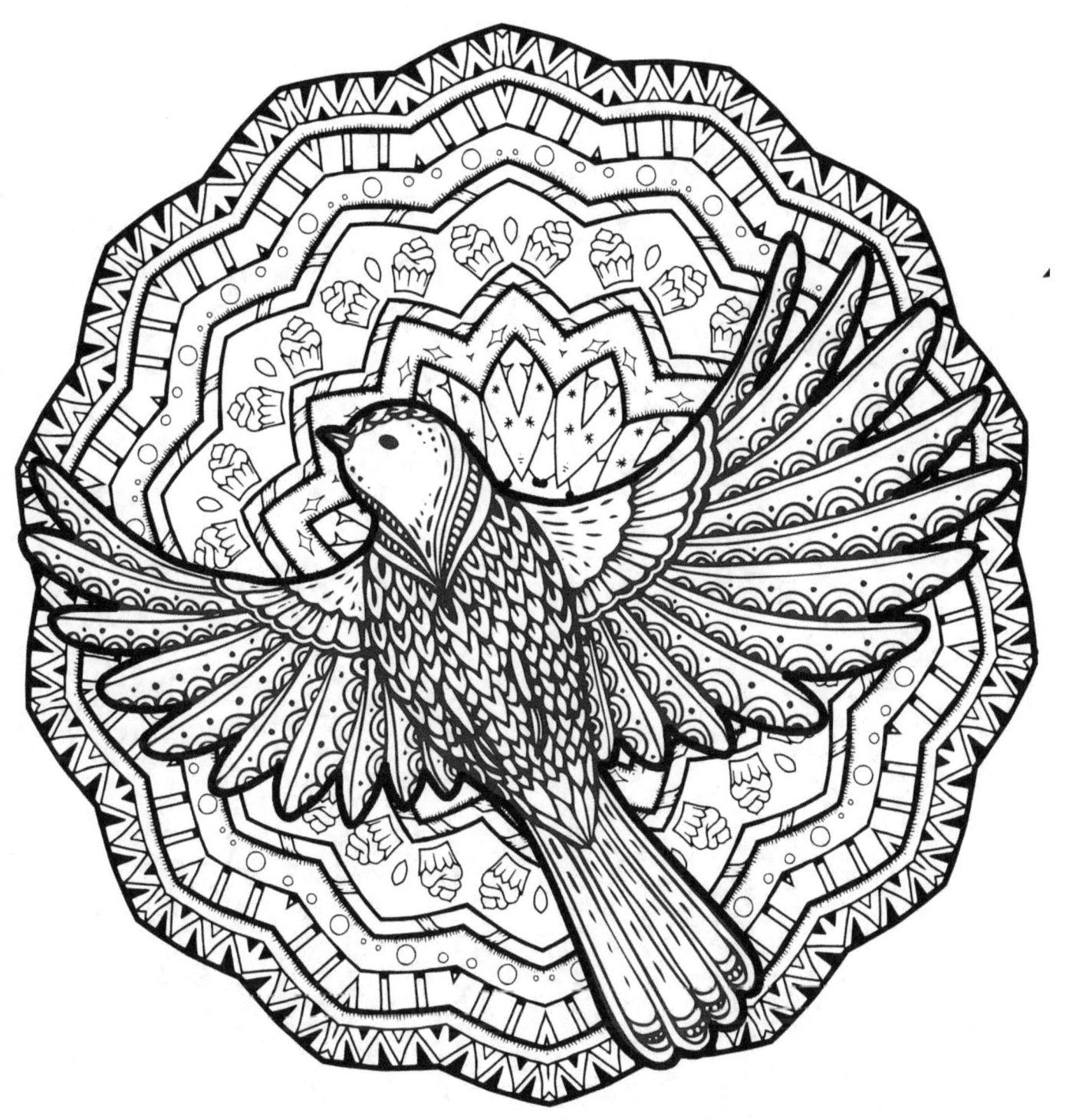

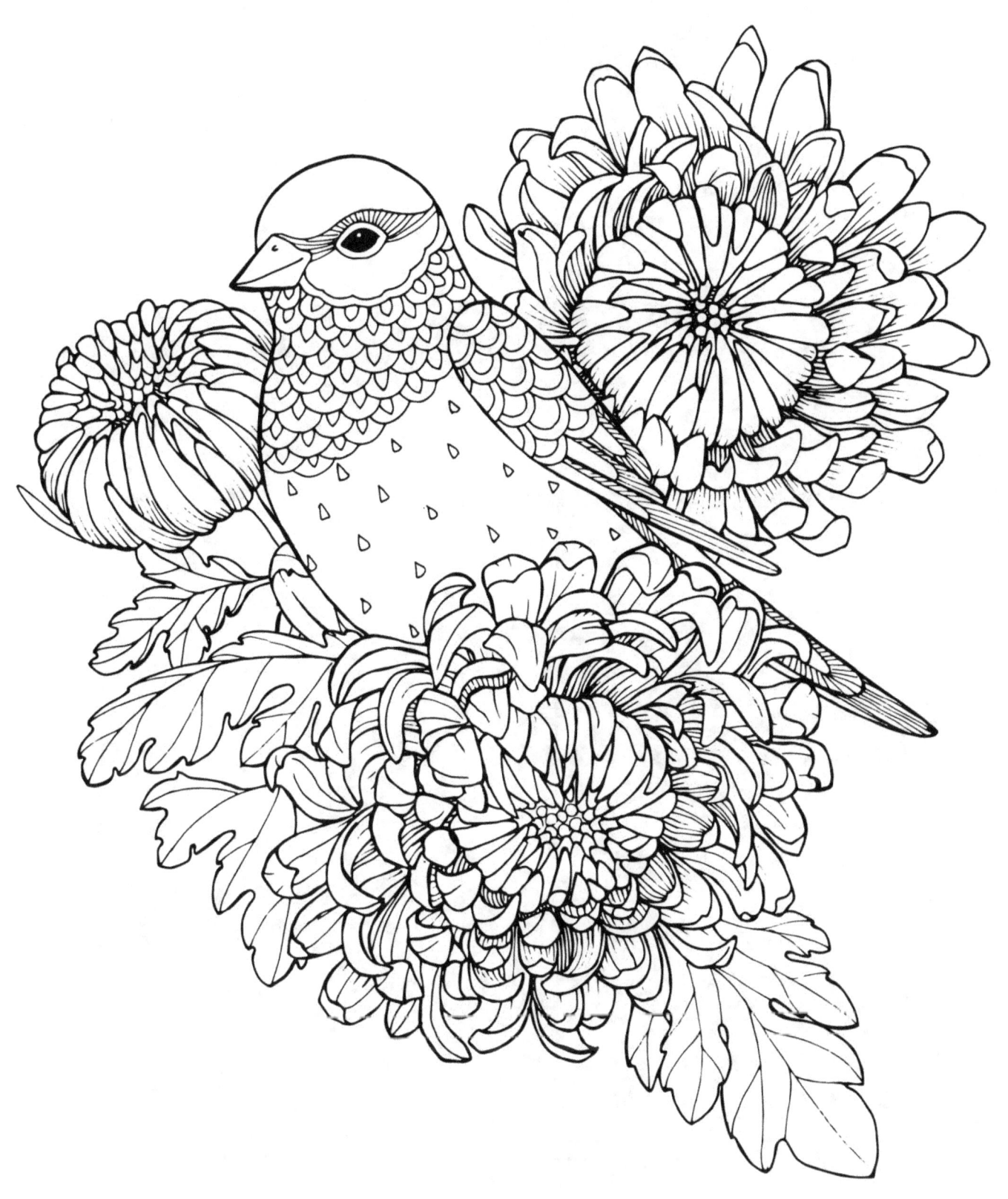

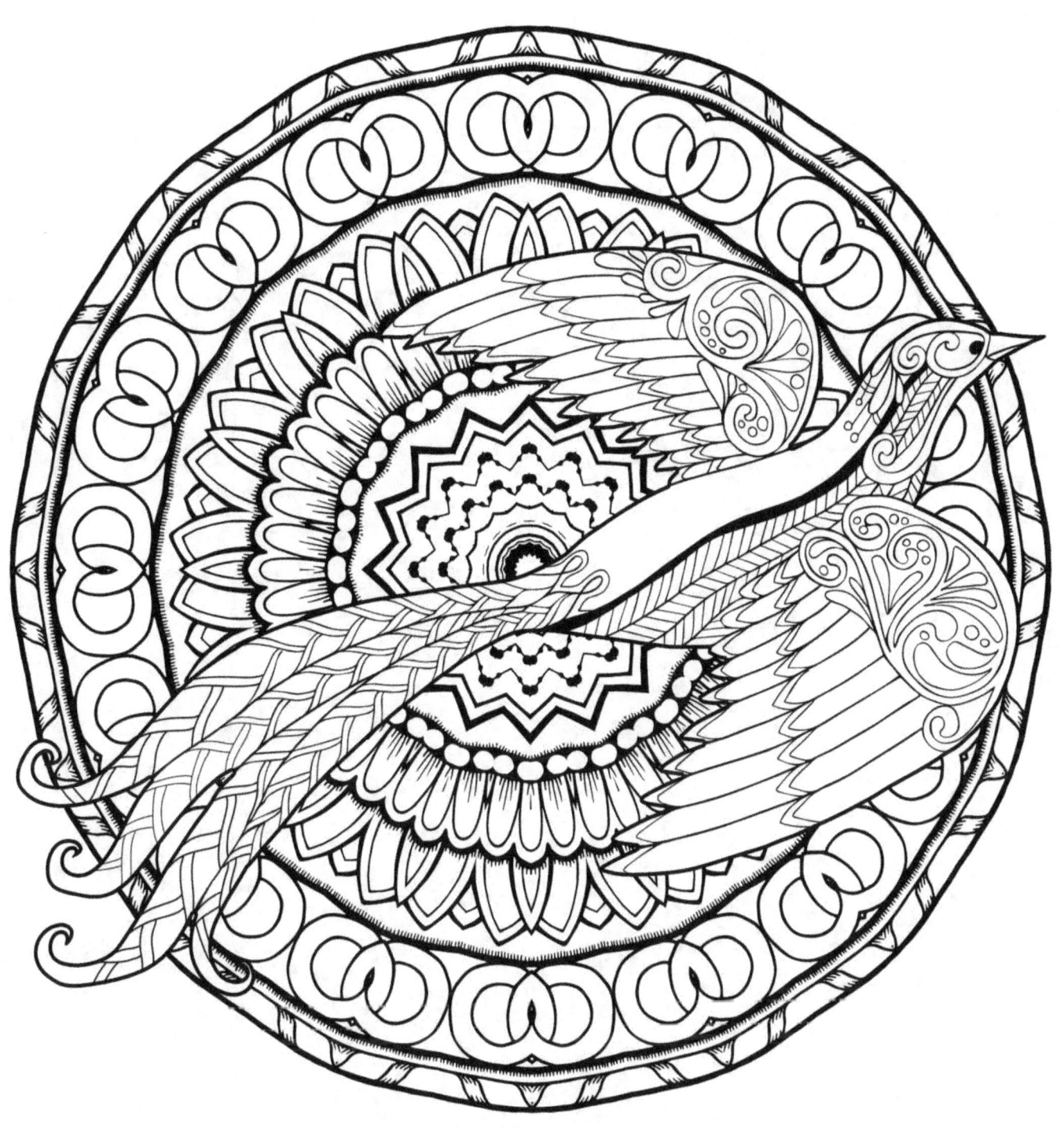

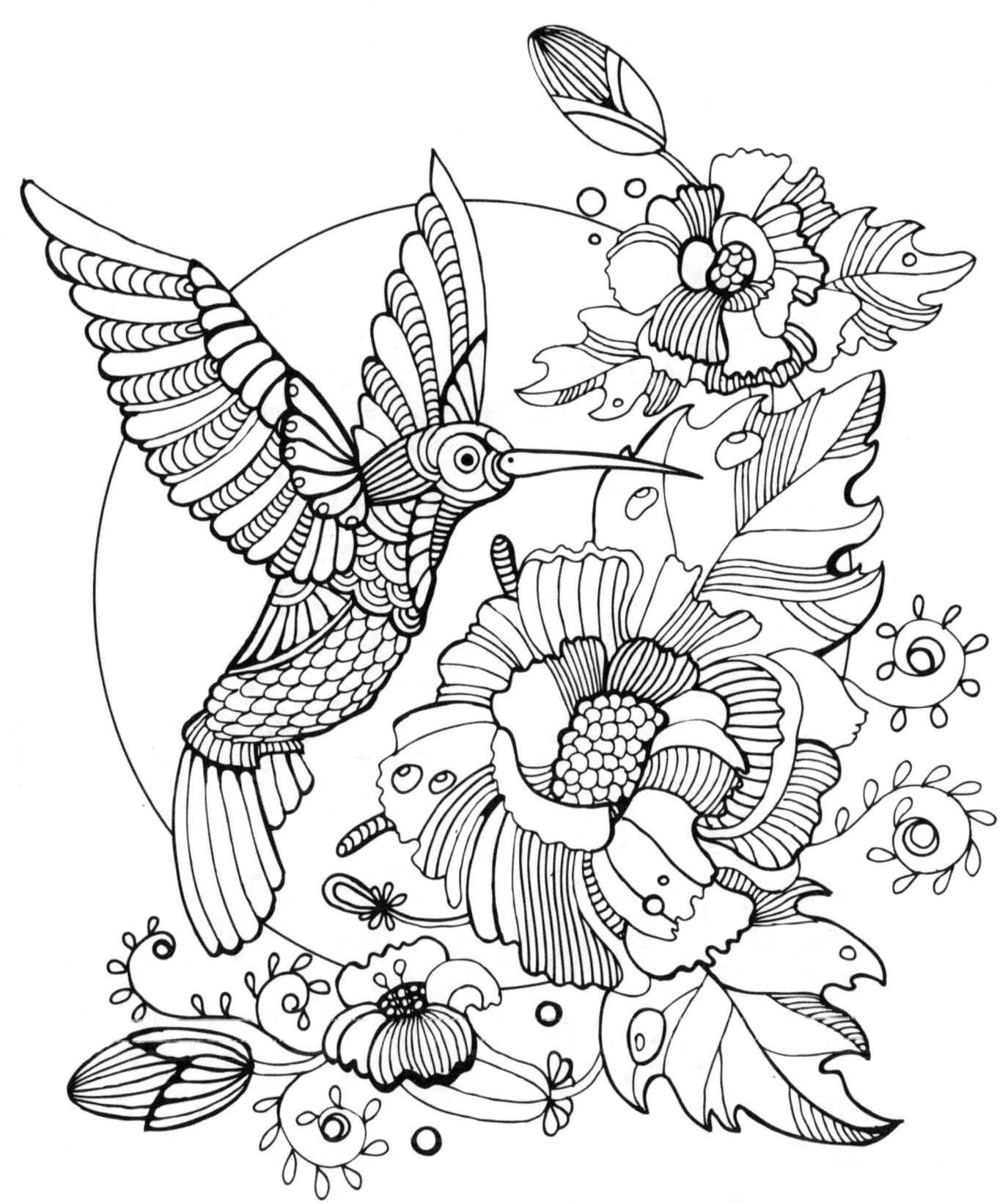

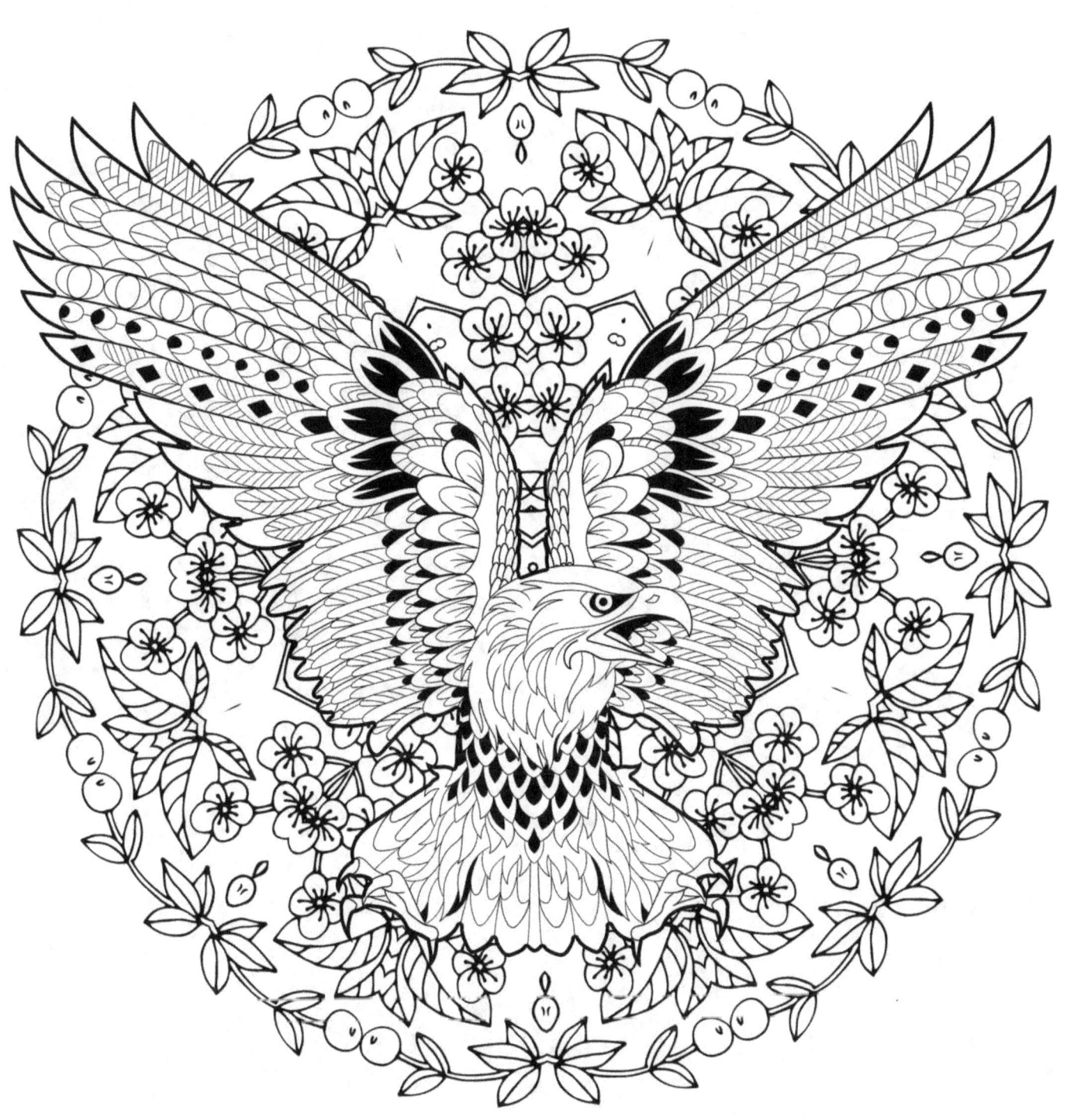

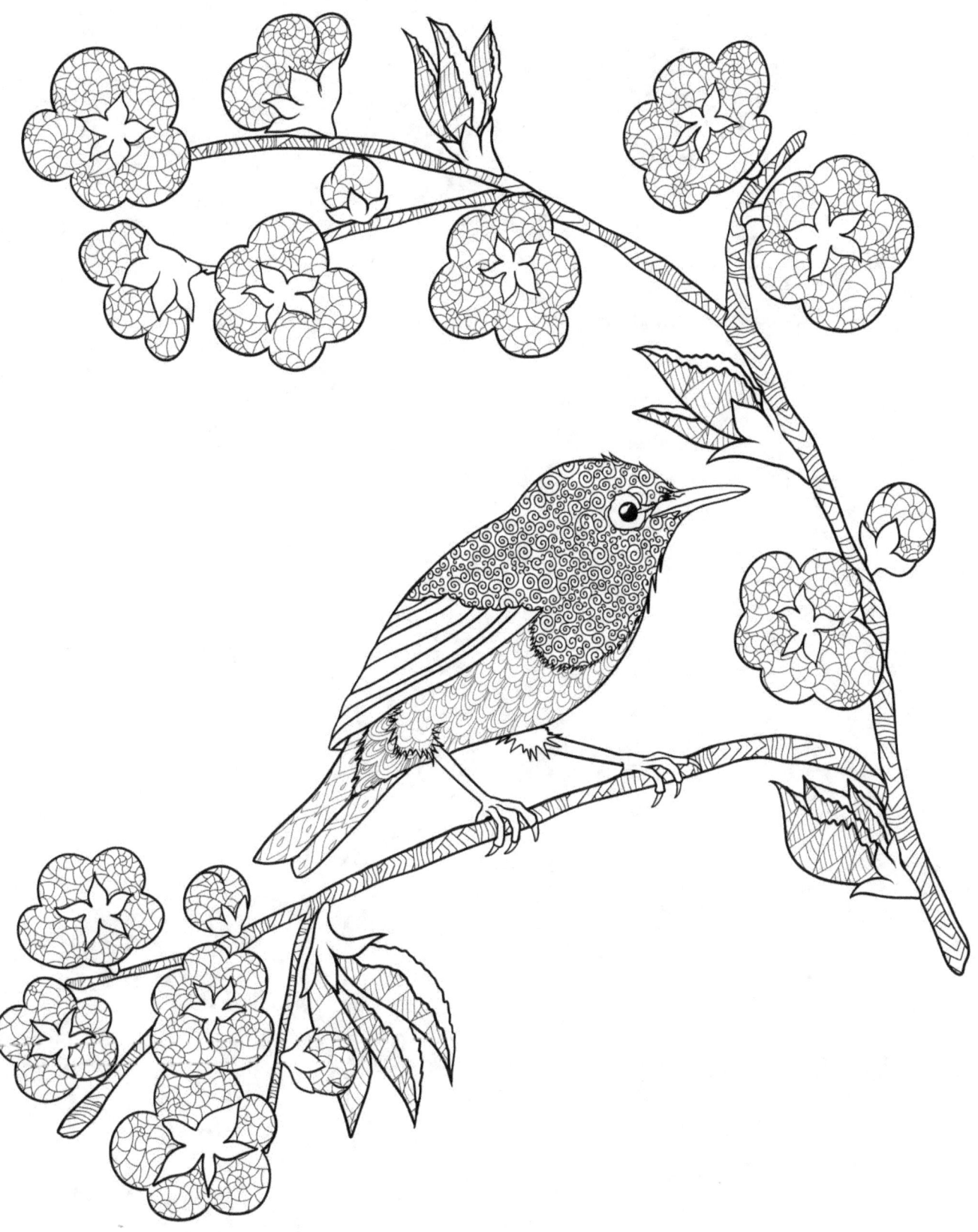

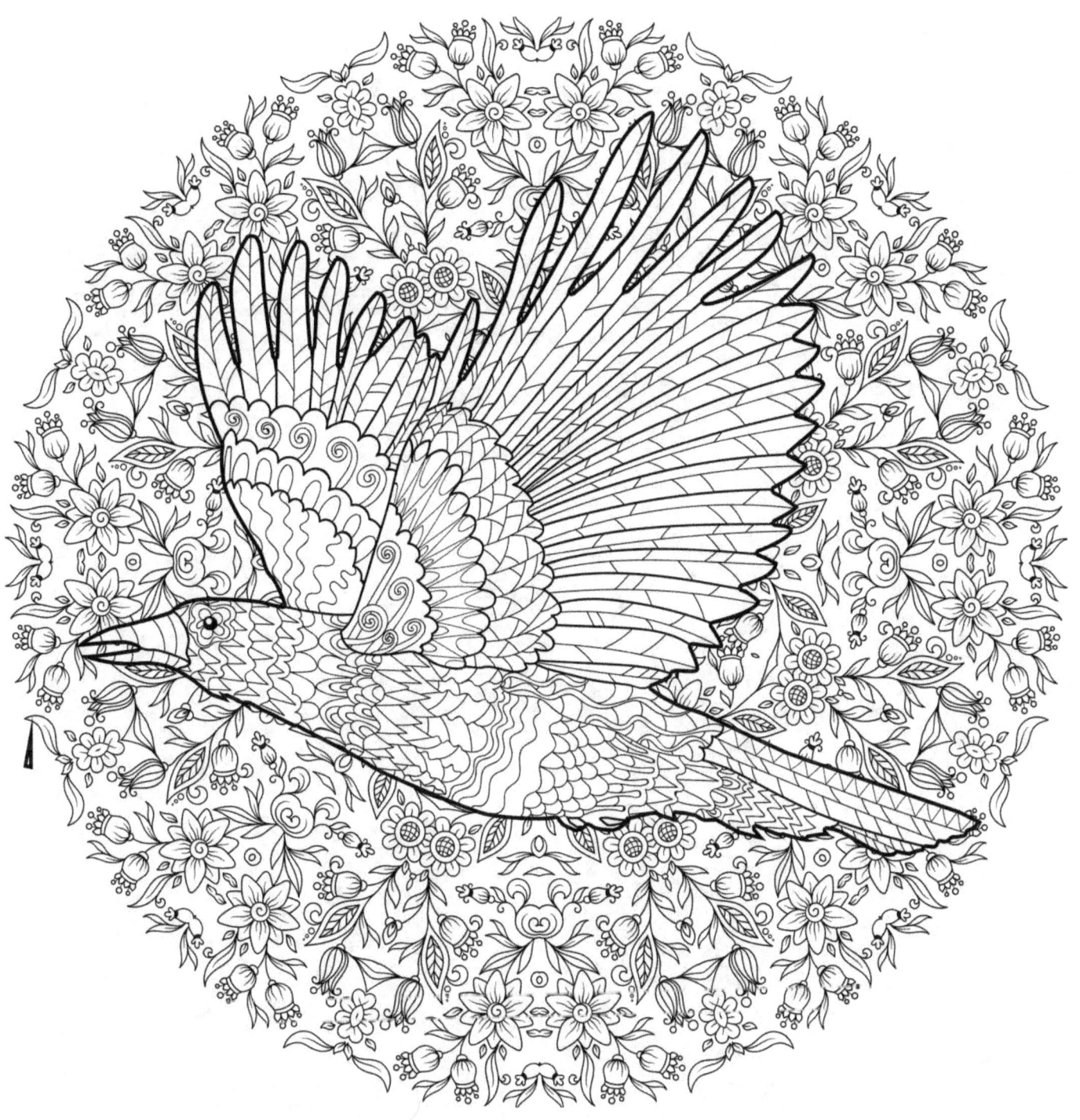

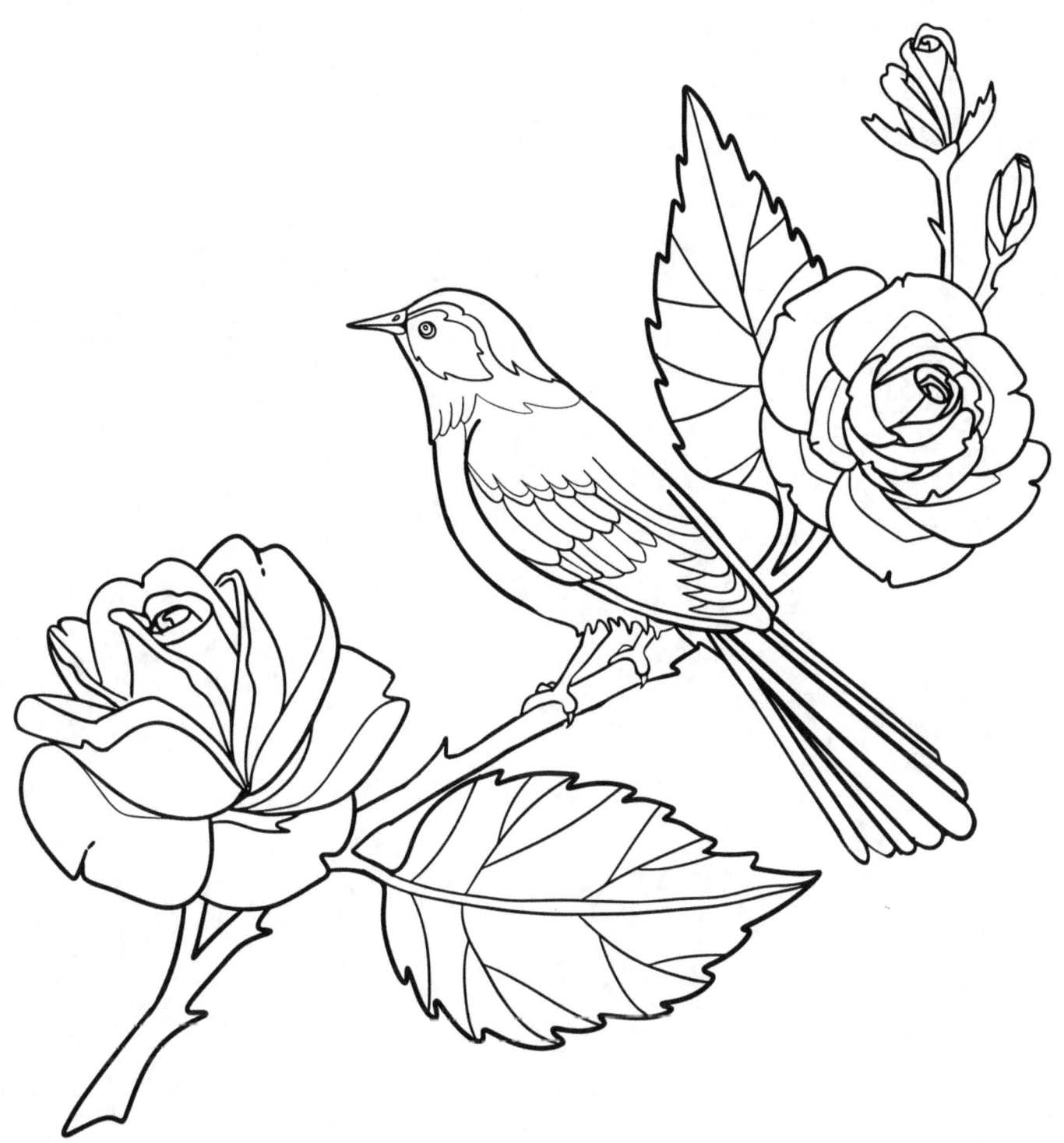

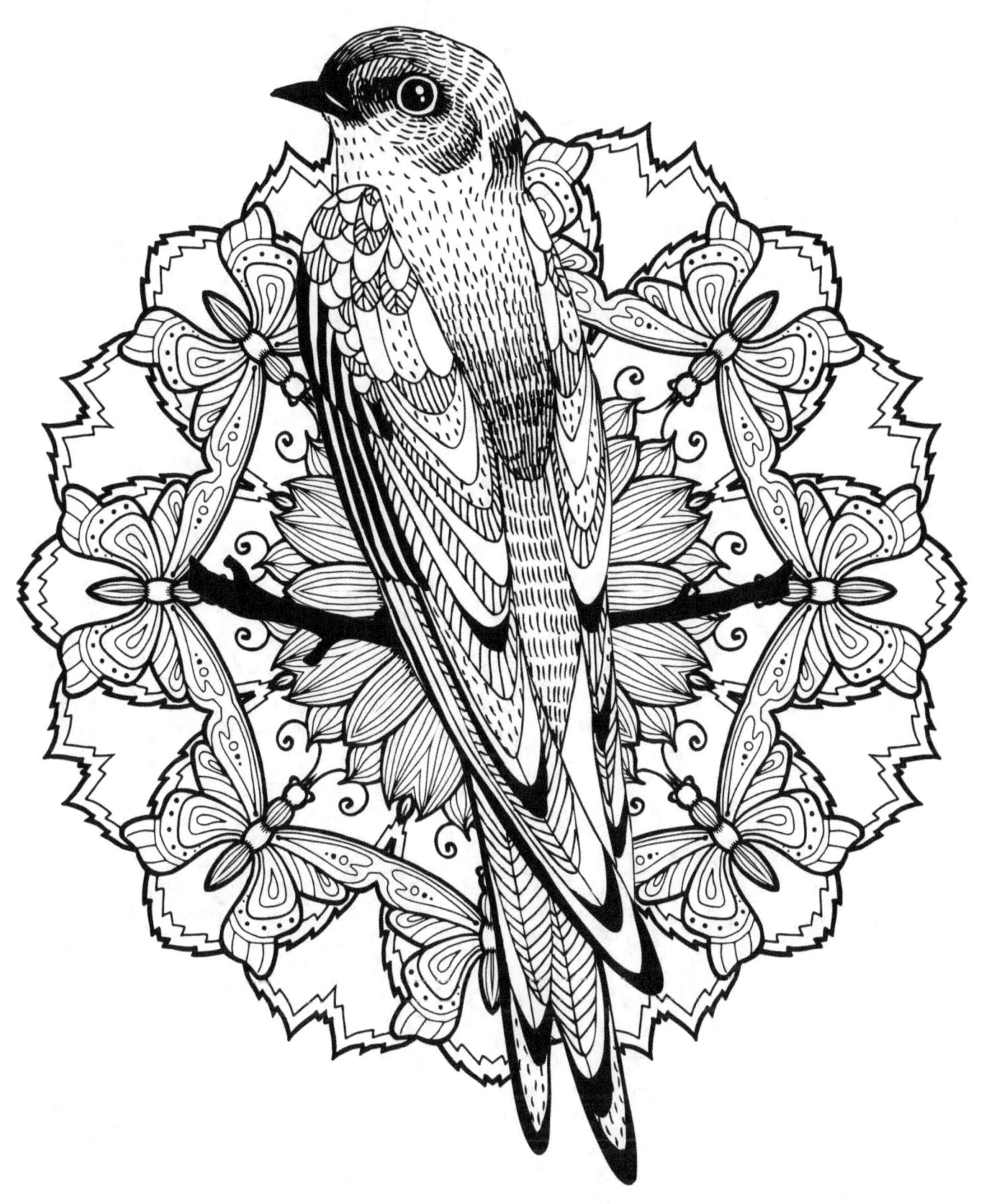

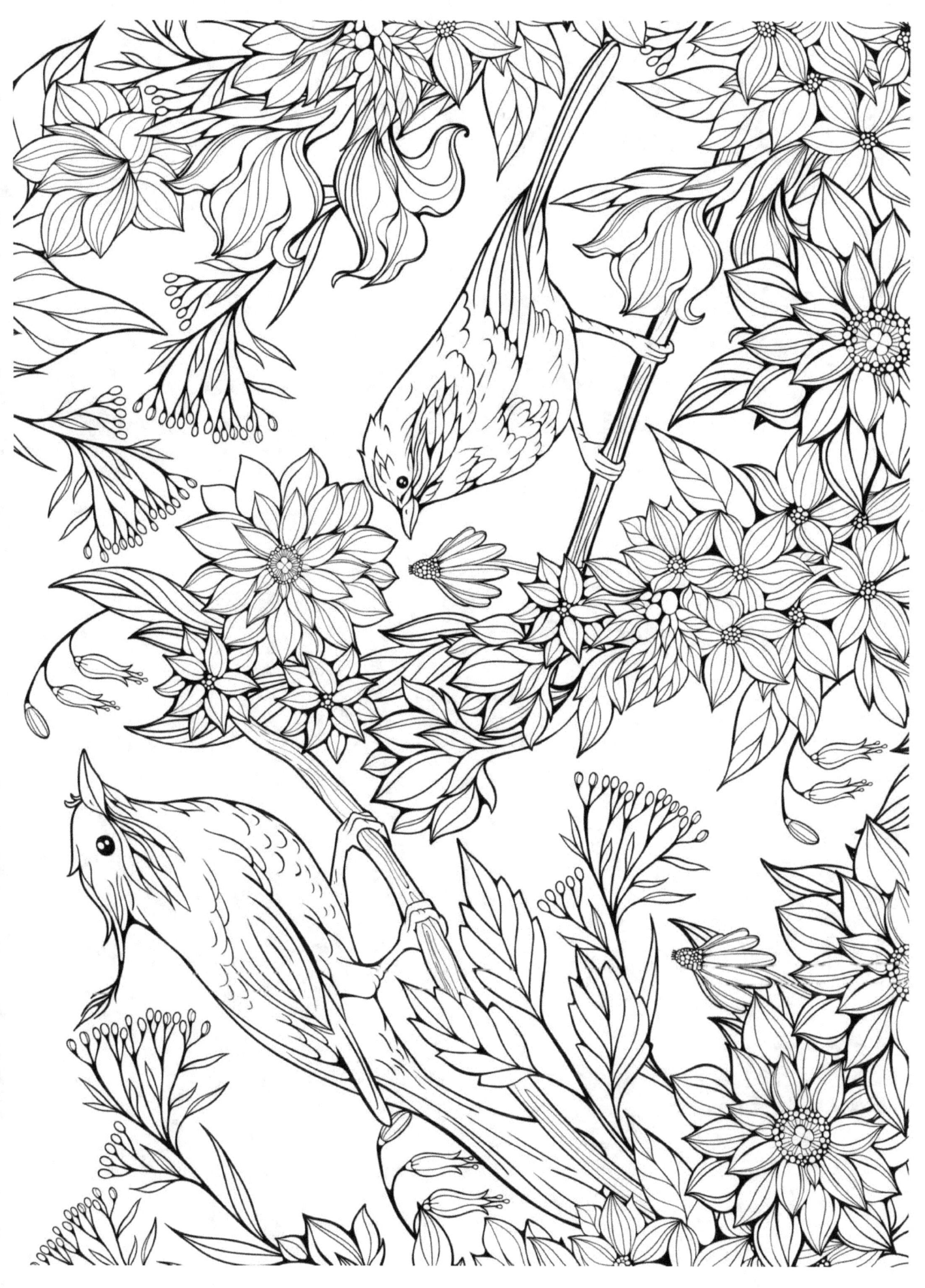

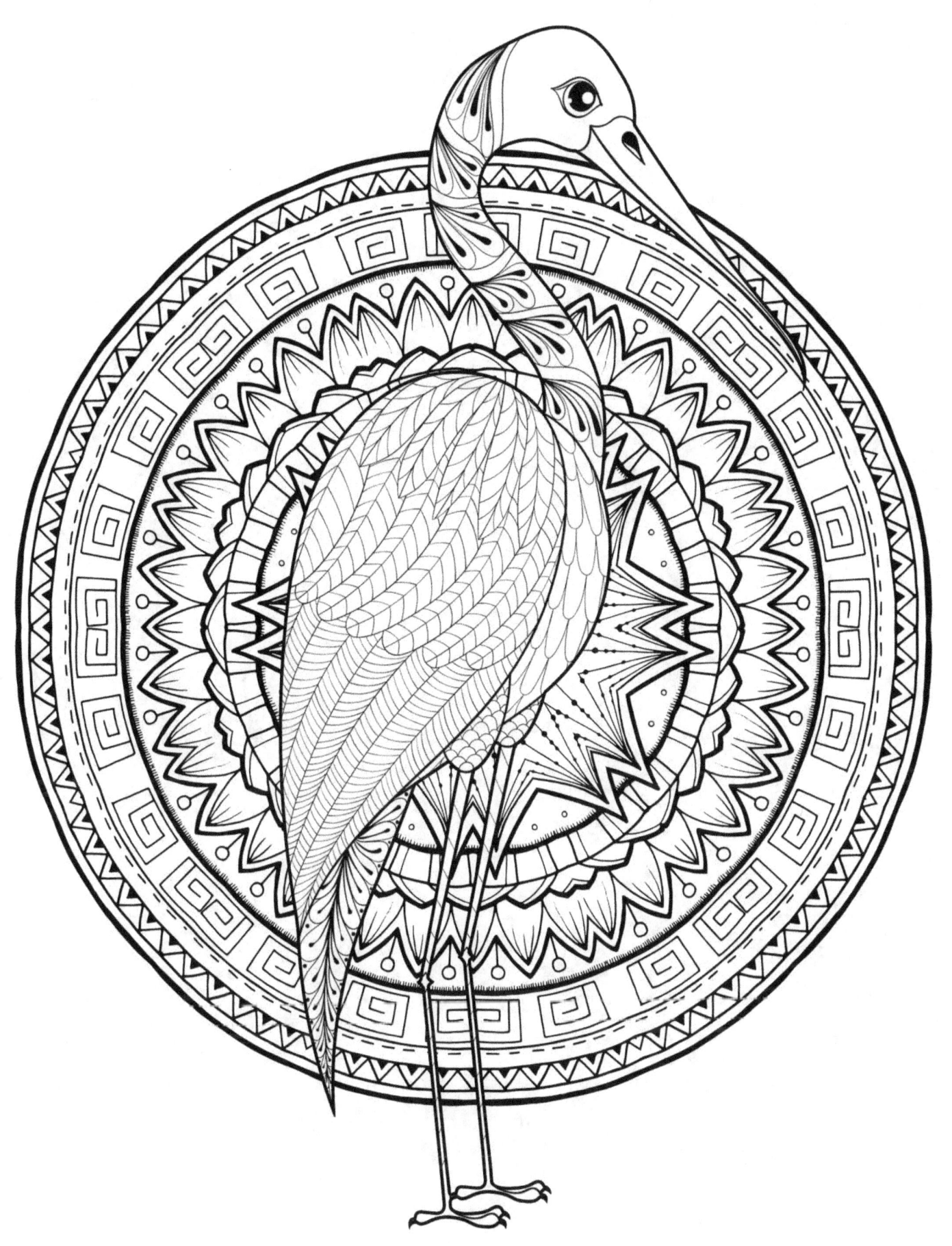

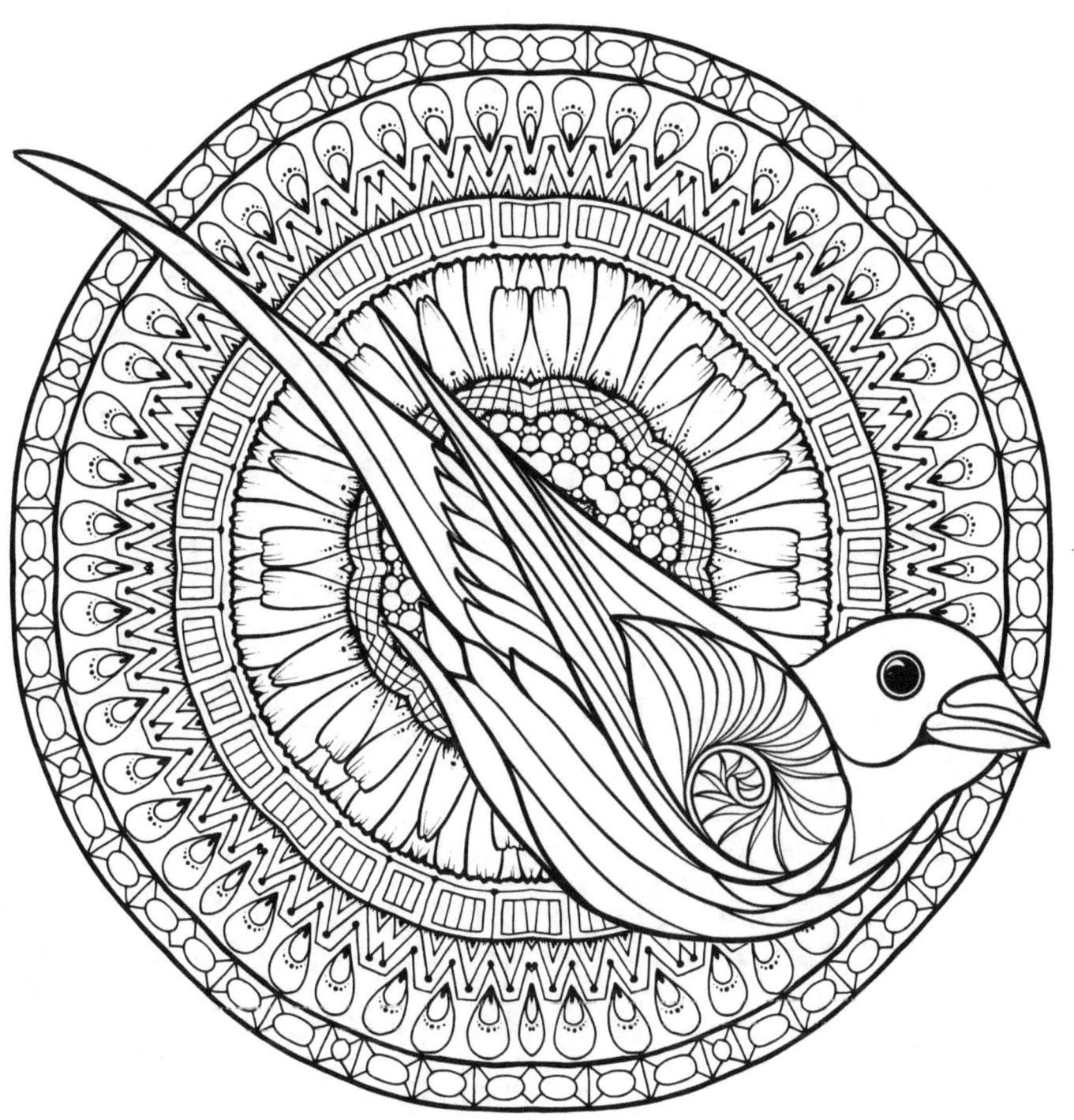

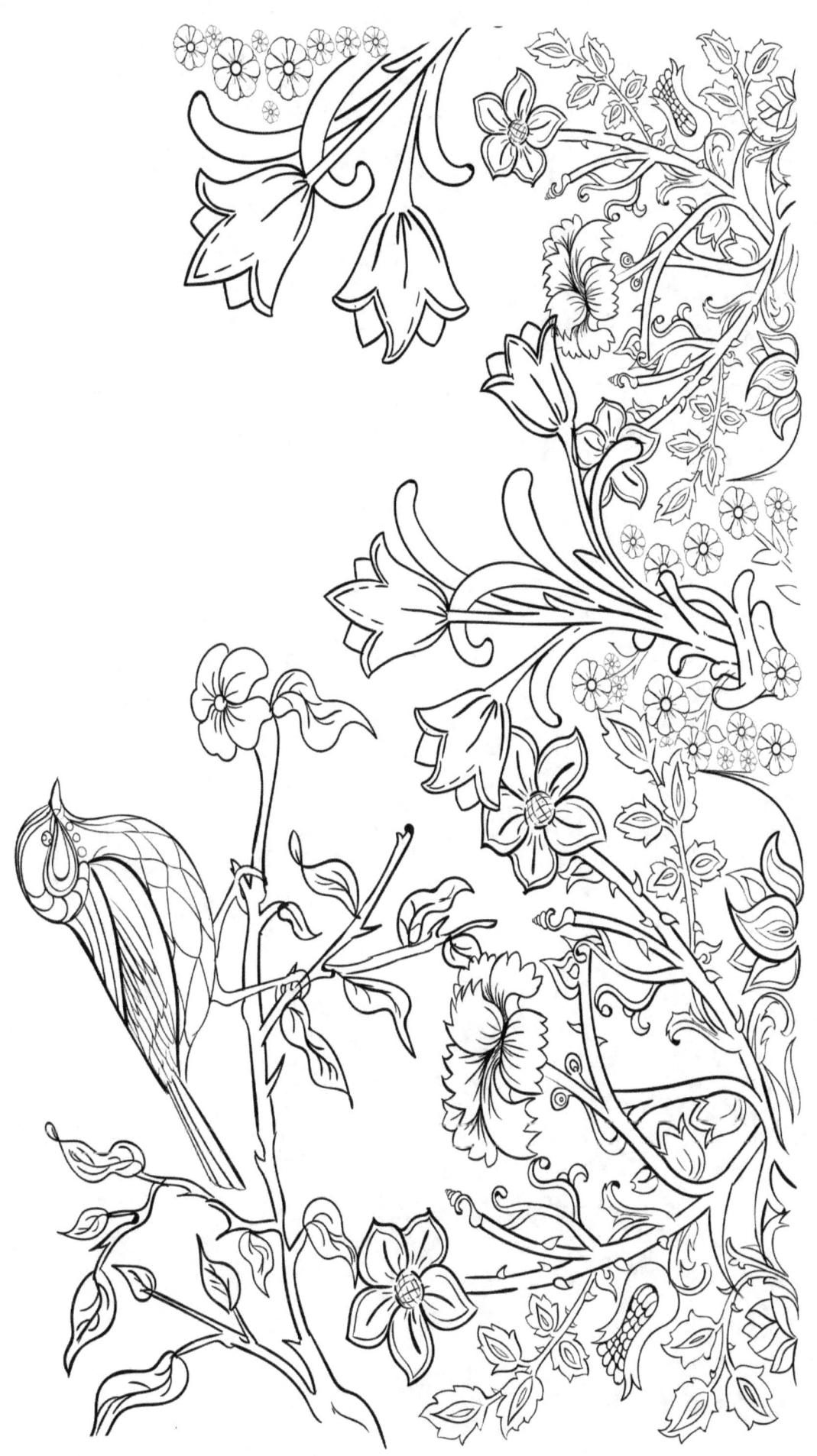

www.ingramcontent.com/pod-product-compliance
Lightning Source LLC
Chambersburg PA
CBHW081125180526

45170CB00008B/3006